DIRECTOR'S CHOICE
SWISS NATIONAL MUSEUM

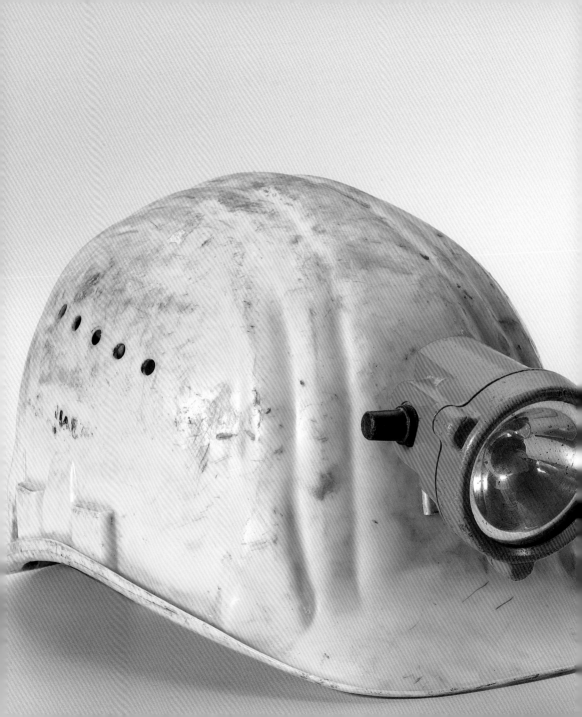

SWISS NATIONAL MUSEUM

Denise Tonella

SCALA

INTRODUCTION

WHEN THE SWISS CONFEDERATION was founded in 1848, there was considerable scepticism about the building of a national museum. At that point, there was no collection covering the whole of Switzerland, and the cantons, which preserved their history in their own collections, were still cautious about the benefits of such a museum. Also, Switzerland had no core stock of ducal or royal possessions on which to build. It was only after the 1850s, when Neolithic pile dwelling settlements were discovered in all regions of the country, that a sense of a common history gradually shifted into focus. A further crucially important stimulus for the establishment of the museum sprang from the first Swiss National Exhibition in Zurich in 1883, which delighted the public through its presentation of outstanding arts and crafts from all parts of Switzerland. The Confederation subsequently approved an annual fund for purchasing cultural assets of importance for the country, and this also made it possible to buy back cultural assets that had found their way abroad.

The National Museum Zurich, the largest museum of cultural history in Switzerland, opened in 1898. Over the course of time, this became part of the present-day Swiss National Museum, which is comprised of not only the National Museum Zurich, fully restored and extended since 2020, but also the eighteenth-century Château de Prangins by Lake Geneva, the Forum of Swiss History Schwyz and the Collections Centre in Affoltern am Albis. The National Museum's collection is continually growing and, with over 870,000 objects dating from prehistoric times to the present day as well as several million photographs, it houses the largest stock of cultural and historical objects in Switzerland.

Today, 125 years after its foundation, the Swiss National Museum is tasked with tackling the diverse identity and culture of Switzerland. It is a place where knowledge is exchanged and a setting for meetings and discussions. Its range of on-site and digital facilities is aimed at a wide audience and offers a varied, multi-perspective view of Swiss history. The museum addresses current social issues in its exhibitions, thus showing its commitment to encouraging visitors to reflect and, by making use of the past, to provide them with tools that will enable them to better understand the present-day world, broaden the way they view their own lives, and

The National Museum Zurich with the new wing opened in 2016.

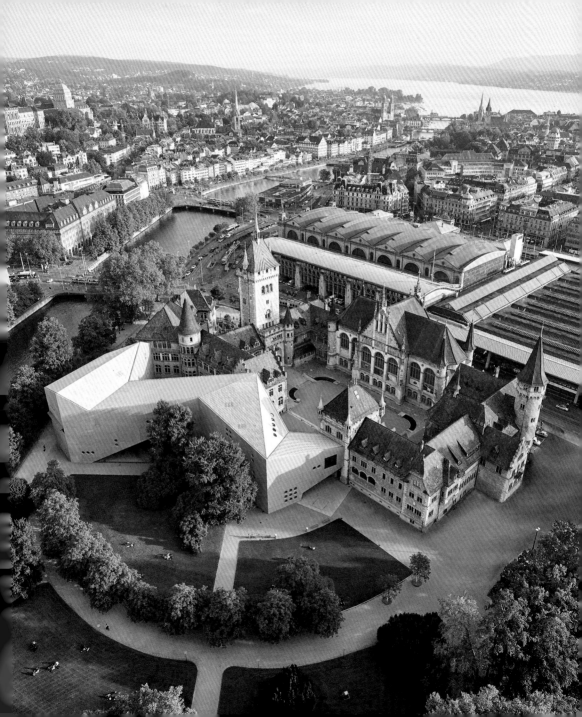

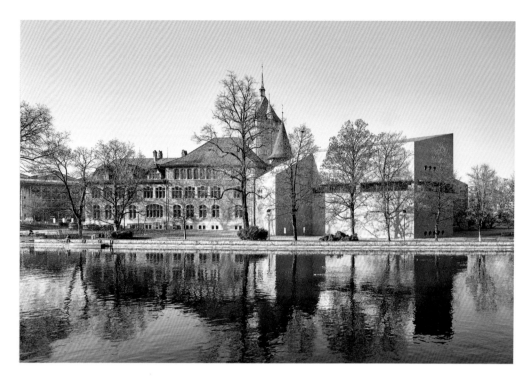

build a bridge into the future. In this book you will discover a selection of gems that will give you a glimpse of the breadth and variety of the cultural heritage in our collection and invite you to take part in a journey from the Neolithic age to the present day.

The National Museum Zurich seen from the river Limmat.

The Château de Prangins and its historic vegetable garden.

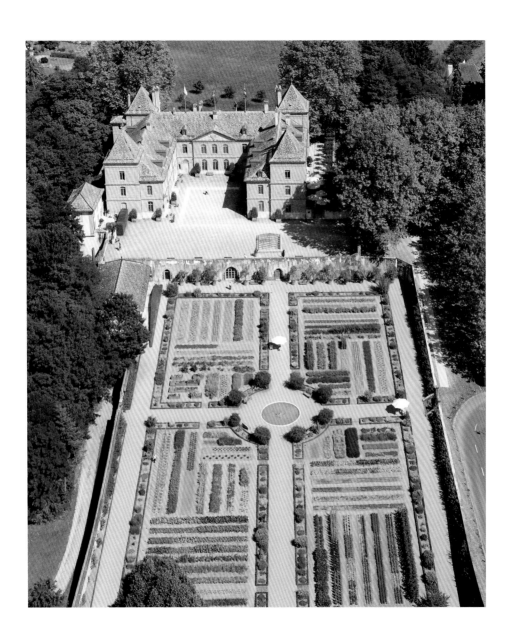

The Forum of Swiss History Schwyz.

The Collections Centre, detail.

Since 2007 the former armoury has been the Collections Centre of the Swiss National Museum.

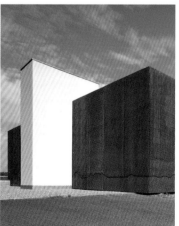

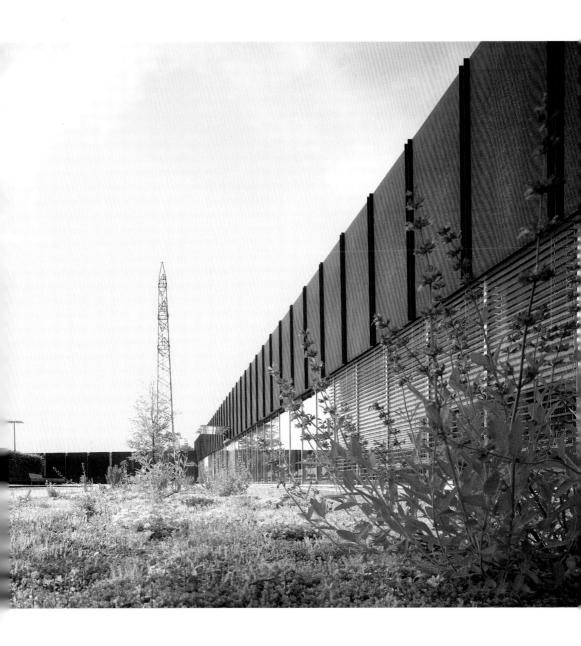

Door, c. 3700 BC

Find site: Robenhausen, district of Wetzikon (Canton of Zurich)
Silver fir
160 × 65 × 6 cm
Inv. no. A 432

THE OLDEST DOOR YET FOUND IN EUROPE comes from an area of marshland to the east of Zurich. It is one of the most spectacular wooden objects from the Neolithic period to have been discovered in modern-day Switzerland. Radiocarbon dating has established that the door from Robenhausen in the district of Wetzikon was created around 5,700 years ago and therefore originates from what is known as the Pfyn Culture, which left its mark on the foothills of the Alps from about 3900 to 3500 BC.

Doors from the Neolithic period are rare finds. It is assumed that at that time wooden doors were reserved for special buildings such as assembly halls or storehouses. One notable feature is the spur on the bottom part of the door, which would originally have been inserted into the threshold and served as a pivot. Five holes bored in one of the long sides were probably there to fasten the door into the frame.

The door was excavated on 15 June 1868 by the farmer and pile-dwelling specialist Jakob Messikommer. He wrote to the Zurich archaeologist Ferdinand Keller: 'Yesterday I found a kind of table, that is, a board about 4 feet long and 2 feet wide with holes in it'. It was found in the Robenhauser Ried, a wetland located at the southern end of Lake Pfäffikon. There, hidden under layers of peat, are the remains of prehistoric marshland settlements that were discovered by chance in 1858. Messikommer sold a large number of the finds he unearthed there to museums all over the world in order to finance his excavations. Just a few selected finds, including the door that is now in the Swiss National Museum, came into the possession of the Antiquarian Society of Zurich, which handed over its collections to the newly established Swiss National Museum at the end of the nineteenth century.

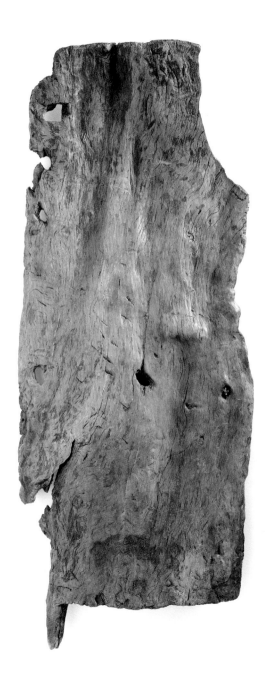

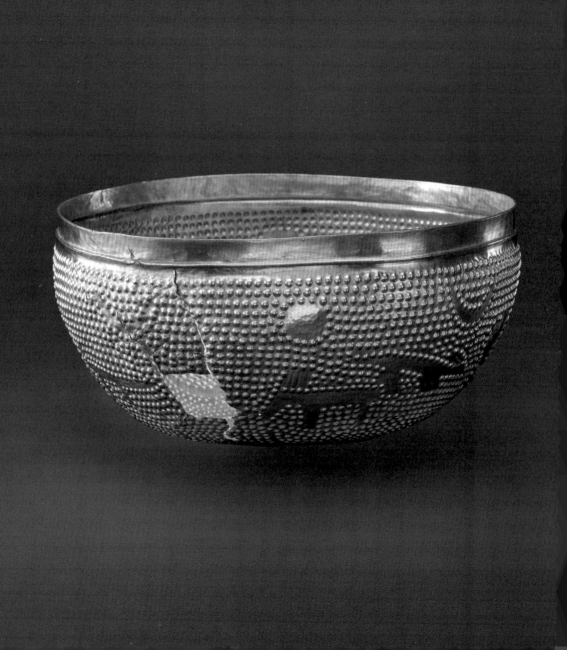

Gold bowl, *c.* 1100 BC

Find site: Zurich–Altstetten
Alluvial gold, 22 carat, repoussé, engraved
H. 12 cm, diam. 25 cm; weight 907.8 g
Inv. no. A 86063

ON 17 OCTOBER 1906, a construction worker laying the tracks for the
Zurich–Altstetten railway line came across a broken clay vessel, in which
a bowl made of pure gold weighing just under a kilogram was discovered:
a valuable, Late Bronze Age bowl, 3,000 years old and one of the most
important gold finds in Europe from this early era. The spectacular find is
shrouded in mystery. The bowl had originally been placed with its open-
ing facing downwards at the bottom of a shaft. It was probably used for
ritual purposes. Despite immediate further investigations, no other finds
were made nearby. Was it a votive offering or was the bowl used as a
burial urn?

The vessel is decorated with raised bumps and several figures. Four
crescent moons and four circles representing the sun or the full moon are
easily recognisable. The middle part is ornamented with fine repoussé
work depicting seven animals, including a stag and possibly a hind, sev-
eral goat-like animals and one that is probably a fox. In this period, people
were already aware of the connection between the changing seasons and
the courses of the stars, as well as the influence of the sun and moon on
the natural world. The positions of the stars and the phases of the moon
determined the time for sowing and harvesting.

The area of damage was caused by the workman's pickaxe. Apart from
that, the vessel survived almost undamaged for several thousand years.
The gold probably originates from Swiss rivers and streams.

Beaked jug, 4th century BC

Find site: Giubiasco (Canton of Ticino), grave 32
Bronze
35.5 × 19.5 cm, diam. 17 cm
Inv. no. A 14045

THIS IRON AGE BEAKED JUG comes from one of the largest burial sites in Switzerland and one of the richest in finds. In the early twentieth century a cemetery comprised of 565 graves with material remains extending from the Late Bronze Age to imperial Roman times was discovered in Giubiasco near Bellinzona. The finds represent a priceless source of information on the prehistory of the southern Alpine region. Uncontrolled treasure hunting in large parts of the burial ground resulted in the loss of countless objects and the destruction or displacement of grave goods. In 1905 the Swiss National Museum intervened and carried out an excavation that enabled a number of graves to be preserved and scientifically documented.

The historical importance of Giubiasco was linked to its special geographical location as a trade-route junction, at the meeting point of the roads through numerous passes and the route along Lake Maggiore. Control over the trading posts and the routes through the passes enabled the resident population to play an important part in trade and in the exchange of products and ideas.

Our beaked jug originally contained wine from central Italy. It came from a local workshop and was found in an Iron Age grave. Its shape is based on Etruscan models. The lavish chased and engraved decoration running over the jug is also adopted from the Mediterranean area. It is possible to make out the inscriptions IAKIR and KOP on the handles. The letters are from the Etruscan alphabet, whereas the language is Celtic. These two words are among the earliest pieces of written evidence from the area of present-day Switzerland. Bronze jugs of this type were prestigious objects passed down from generation to generation. Along with cups of maple wood and ceramic beakers, these grave goods accompanied the dead into the next world.

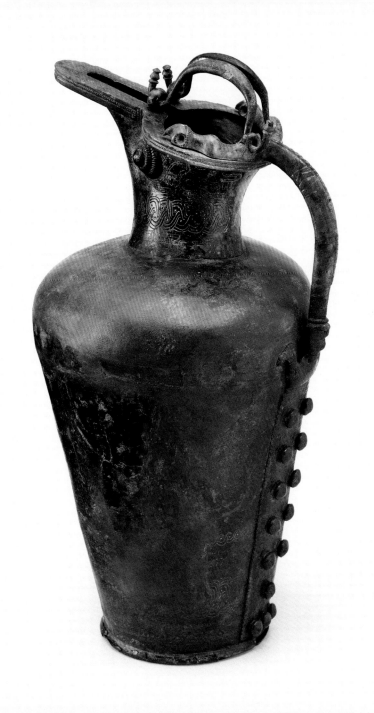

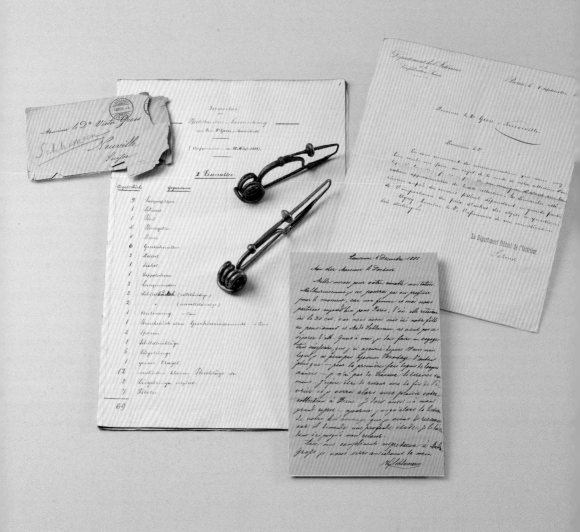

Fibulae, 3rd century BC

Iron
Find site: La Tène, Marin-Epagnier (Canton of Neuchâtel)
11.2 × 2 × 3 cm, 15 × 2 × 1.5 cm
Inv. nos. A 10550 and A 76271

THE INHABITANTS OF PILE DWELLINGS left their mark on the development of Swiss identity in the nineteenth century, and the material belongings they left in the lakes and marshes are among the most important sources for Central European archaeological research. One of the most significant find sites is that of La Tène on the eastern shore of Lake Neuchâtel. Some 2,500 objects were excavated here in the nineteenth century, including pieces of wood and leather, weapons, work tools and agricultural implements, horse harness, plates and bowls, rings and brooches. Among the brooches are the two items shown here, although these are now ascribed to the sphere of Celtic culture. Not only the inhabitants of the pile dwellings, but also the Celts were regarded as ancestors of the Swiss.

Both private individuals and organisations participated in the excavations. The prehistoric finds were not only coveted collector's pieces but also lucrative trade goods, which were sold over five continents. The two fibulae entered the pile-dwellings collection of Dr Victor Gross (1845–1920), which was bought by the Swiss Confederation in 1884 and thus saved from sale abroad. They are among the first items to appear in the inventories of the Swiss National Museum. The documents surrounding the two fibulae in the illustration form part of the inventory of finds. They include a letter of 1884 from Carl Schenk, a member of the Federal Council, requesting information about the price and value of the collection as a whole; and a letter dated May 1885 from Heinrich Schliemann – the discoverer of the ruins of Troy – to his friend Victor Gross.

The majority of the finds from La Tène are now kept in the Swiss National Museum and in the Laténium, the archaeological museum of the Canton of Neuchâtel.

Tremissis, undated (*c.* 600)

Merovingian realm, Theodoric II (587–613)

Gold, stamped, diam. 1.1 cm, 1.22 g

Obverse: VINDONISSE FITVR; bust with diadem facing right

Reverse: TVTA MONE[TA]R[I]VS; cross on triangle, globe below

Inv. no. M 6678

THE SWISS NATIONAL MUSEUM's Coin Cabinet contains about 100,000 objects, from the earliest minted to currently valid coins and banknotes. The core of the collection is the hoard of around 30,000 Swiss coins, which makes it the largest of its kind. This important collection includes coins of Merovingian rulers minted in what is modern-day Switzerland. The gold coin selected here comes from the time of Theodoric II, king of the Franks in Burgundy, famous for military conflicts with his brother Theudebert II. In 612, Theodoric defeated his brother and ordered his execution, before dying himself shortly afterwards at the age of only 25.

The coin was minted in the former Roman legionary camp of Vindonissa, modern-day Windisch in the Canton of Aargau, by a minter by the name of Tuta. It is not known under whose authority. The coin is a tremissis, one third of a solidus, the standard late Roman gold coin. In the Merovingian period coins were almost exclusively minted in gold. Located in a strategically favourable position at the confluence of the Aare, Reuss and Limmat, in Roman times Vindonissa was an important legionary camp. From there the soldiers kept watch on the trade routes leading northwards to Germania and southwards to the Alpine passes. Outside the legionary camp a civilian settlement developed with an amphitheatre, public baths and two temples. By around 100 AD it already had some 10,000 inhabitants and was developing into a commercial and cultural magnet. After the fall of the Roman Empire, Vindonissa rose to become a cathedral city and the site of a mint. Our tremissis, minted in about 600 AD, confirms that Vindonissa was still a regional centre at that time.

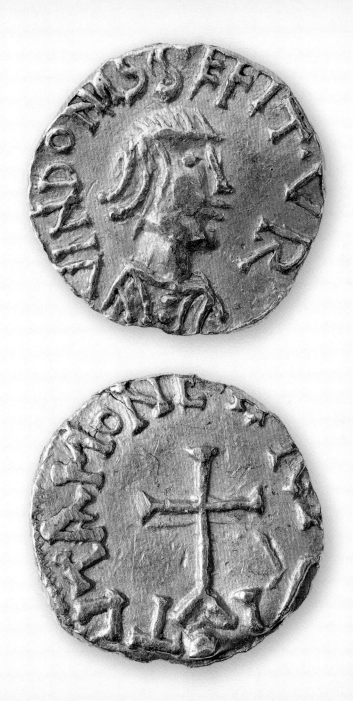

Enthroned Virgin with Child, probably Raron (Canton of Valais), *c.* 1150

Lime wood, painted
90.5 × 25 × 33 cm
Inv. no. LM 16545

'AS THE QUEEN OF HEAVEN she sits unapproachable, enthroned on an ornate chair with her young prince, who resembles her in body and soul'. That is the description of this almost 900-year-old sculpture in the 1924 annual report of the National Museum Zurich. This *Enthroned Virgin with Child* is among the earliest of the seven hundred or so sculptures in the museum's collection. Created in the twelfth century, it is one of the most important Romanesque artworks in Switzerland. The circumstances surrounding its discovery are amazing and regularly cause the eyes of visitors on guided tours to light up. During the restoration of the parish church of Raron in 1924, seven medieval wooden sculptures that had been covered for centuries by skulls and skeletons were discovered in the underground charnel house. They had probably been dumped there during the rebuilding of the church between 1510 and 1515, because they no longer suited the taste of the time.

The Virgin Mary, sitting stiffly upright, serves as a throne for her son, with her arms forming the chair's rests. There is a hollow in her back that was probably originally intended to hold relics. The wooden sculpture once shone with rich colours: gleaming golden yellow for the tunic of Christ, blue for his outer garment, green and vermilion for the Madonna's robes. In addition, polished stones and glass that have now been lost would have made the crowns sparkle. Numerous early wooden sculptures have been preserved in the monasteries and chapels of the Swiss Alpine valleys. In the early decades of the twentieth century they were under threat of being sold abroad. For this reason, many of them were taken into the collection of the Swiss National Museum as important records of the Middle Ages.

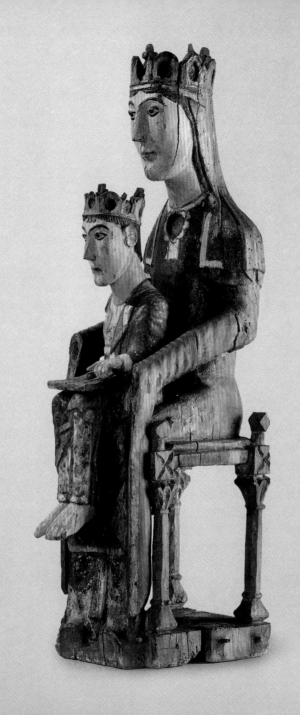

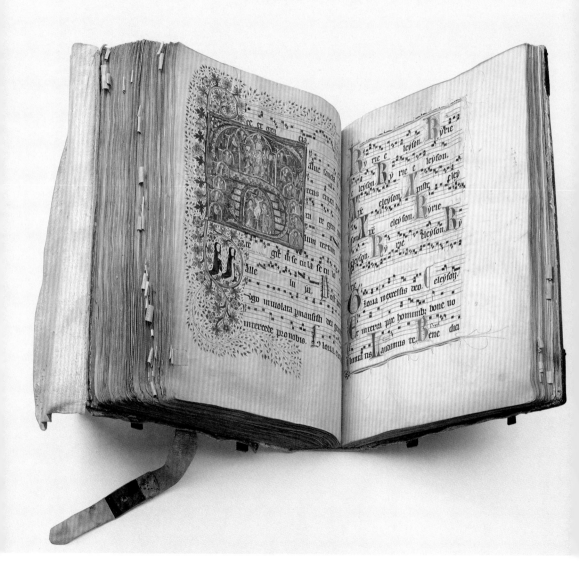

Gradual, St Katharinental Convent near Diessenhofen
(Canton of Thurgau), *c.* 1312

Parchment codex with leather-bound wooden cover (15th century) and metal clasps, 314 folios

48.5 × 33.5 × 20 cm, 12.2 kg

Inv. no. LM 26117, co-owners: Canton of Thurgau and Swiss Confederation

(Gottfried Keller Foundation)

THIS WONDERFUL MANUSCRIPT originates from the Dominican Convent of St Katharinental near Diessenhofen in the Canton of Thurgau and is of great value for Swiss spiritual, liturgical, artistic and cultural history at the start of the Late Middle Ages. It is a gradual, containing the text and music for the High Mass. Created in the convent itself around 1312, it was probably illuminated in the region around Lake Constance. Every single one of the over six hundred pages has nine staves with the Latin text of the chants underneath. The double pages are over half a metre wide because the gradual was used as a shared hymnal and therefore had to be legible from relatively far away.

The hides of dozens of animals were used for the manuscript, which weighed over 12 kilograms. The book is extremely richly illuminated with over eighty fleuron initials, more than sixty historiated initials and five I initials, ornamented with biblical scenes. The flower friezes portray numerous kneeling and praying Dominican nuns, a few Dominican monks and a number of secular donors to the manuscript. At least six hands were involved in the magnificent ornamentation.

The gradual was in use in the convent into the nineteenth century. In 1821 or shortly before that, it came into the possession of Franz Joseph Aloys Castell, an antiquarian in Constance. After 1860 it belonged to the English collectors Sir William Amherst of Hackney and Sir Charles Dyson Perrins. After the latter's death, his manuscript collection was put up for sale by Sotheby's. In 1958 the manuscript was jointly acquired by the Swiss Confederation, the Gottfried Keller Foundation and the Canton of Thurgau.

Flag, main Zurich banner, place of production unknown, 1437

Silk damask

129 × 112 cm (without streamer)

Inv. no. KZ 5636

A FEW YEARS AFTER Luther published his 95 theses in 1517, Huldrych Zwingli set the Reformation in motion in Zurich. The Mass, saints and celibacy of priests were abolished and images were banned from churches. The Protestant faith relied entirely on the Bible, which now became available in German. The Reformation spread from Zurich to various cities in German-speaking Switzerland. However, the central cantons of Uri, Schwyz, Unterwalden, Lucerne and Zug clung to the old faith. This soon led to conflict and in 1531 to the Battle of Kappel am Albis. The forces of the Protestant regions could not repel the attack of the Catholic cantons and great losses resulted on both sides. Huldrych Zwingli, who had gone into battle as a military chaplain, was taken prisoner and is said to have been executed on the spot.

The main Zurich banner of 1437, illustrated here, was taken to Kappel on 11 October 1531. The Zurich standard bearer who carried the banner died in the battle. However, two captains from Zurich succeeded in rescuing the banner and bringing it back to the city.

This defeat resulted in the failure of Zwingli's plan to lead the entire Swiss Confederacy into the Reformation, and the Catholic cantons retained their supremacy until the Second War of Villmergen in 1712. Nevertheless, the new faith, Genevan Calvinism in particular, spread further. Virulent religious conflicts in the Confederacy persisted into the nineteenth century. Catholics and Protestants continued to defend their forms of worship. Freedom of worship was not guaranteed until the Federal Constitution of 1848 – and then at first only to Christian denominations.

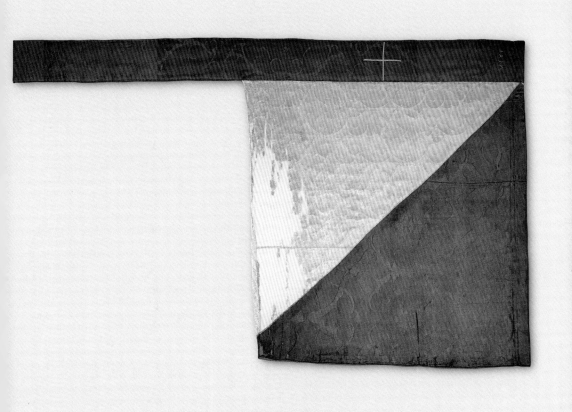

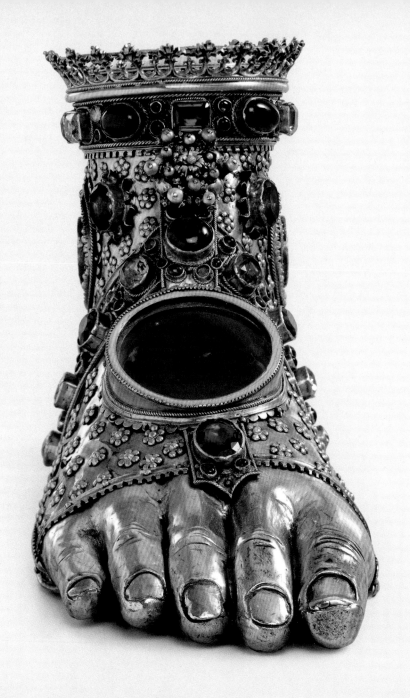

Foot reliquary, probably Basel, 1450

Donor: Oswald Walcher, cathedral chaplain and master of the Mason's Guild of Basel Cathedral

Wrought and partly gilded silver, silver filigree, engraved and gilded copper, enamel, rock crystal, glass stones, mother of pearl, oak

14.2 × 24.1 × 9.8 cm

Inv. no. IN 184

Inscription outside: INTEGER PES DE INNOCENTIBVS SANCTVS COLVMBANVS DEDIT

(St Columban gave a whole foot of [one of the] Innocents)

Inscription inside: OSVALDVS FECIT HOC OPVS DE VOLVNTATE DEY 1450 IAR

(Oswald by the grace of God donated this work in 1450)

THIS SILVER FOOT in a Roman sandal is a reliquary from the Treasury of Basel Cathedral, where the alleged ankle bone of a boy who died in the massacre of the Holy Innocents in Bethlehem was once kept. It is now among the treasures of Mariastein Abbey in the Canton of Solothurn. On 28 December, the Feast of the Holy Innocents, a priest ceremonially carried the foot reliquary through Basel Cathedral. Very precious materials – mother of pearl, silver, rosettes of gold and enamel medallions – were used in the creation of this impressive vessel. Until about 1850, it was set with semi-precious stones and gems, rather than coloured glass. The rock crystal in the instep served as a peephole, through which the faithful could see the tiny bone. The two large medallions at the ankles ornamented with flowers and filigree work in pure gold are a special feature. They originate from a Parisian goldsmith's workshop and were made around 1300. Particular attention should be paid to the mother-of-pearl relief depicting the presentation of the infant Jesus in the temple; this closes the foot like a lid and was probably made for the reliquary by a master mother-of-pearl craftsman in Basel.

It is remarkable that the foot reliquary is now housed in the Swiss National Museum. When Basel-Stadt and Basel-Land split into two cantons in 1833, the cathedral treasure was divided. Basel-Land received two thirds of the chalices, monstrances and robes, but was in desperate need of money and sold its share. The foot reliquary was put up for sale and was bought by the Swiss National Museum in 1892. Basel-Stadt hung on to its share of the cathedral treasure. Visitors can now gaze in wonder at it in Basel Historical Museum.

HANS LEU THE ELDER
(*c.* 1460–1507)

Triple martyrdom of the patron saints of Zurich: Felix, Regula and Exuperantius, Zurich, 1497–1502

Overpainting by Hans Asper (1499–1571), Zurich, probably around 1566

Tempera on wood, 82 × 450 cm

Inv. no. AG 7-8, Swiss National Museum / Zurich Central Library

THE OLDEST SURVIVING panoramic image of Zurich looks back to a legendary story. Hans Leu the Elder painted the altarpiece for the altar of the city's patron saints Felix, Regula and Exuperantius in the Chapel of the Twelve Apostles of the Grossmünster in Zurich. The martyrdom of the patron saints – boiling in oil, breaking on the wheel and beheading – is depicted in the foreground.

According to the legend, the siblings Felix and Regula came to Valais with the Theban Legion in the fourth century and fled from there to Zurich. Because they refused to renounce the Christian faith, the Roman governor had them tortured and beheaded. After the execution, so the legend goes, they carried their severed heads up the hill themselves. Their graves were where the Grossmünster stands today. In later traditions, they were joined by Exuperantius as a servant.

As the background for the martyrdom, Hans Leu chose a very detailed view of the city of Zurich on the left bank of the Limmat. A number of the buildings and churches are still easily recognisable today. In the course

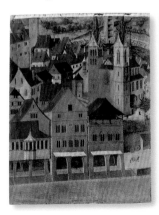
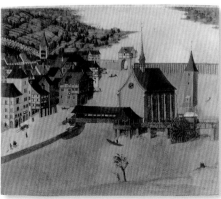
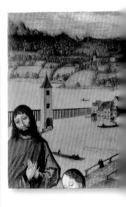

of the Reformation the panels were removed from the Grossmünster, disfigured, and had the lower portions cut off, whereas the view of the city remained undamaged. Around 1566, the parts of the martyrdom that were still visible were overpainted. In the early nineteenth century, the panels reappeared under some old floorboards during the renovation of the Zum Rössli inn. In 1936/37 the top layer of paint was removed from three of them and the figures of the saints became visible again. It is very fortunate that the same was not done to the other two panels as the overpainting during the Reformation period is a part of the history of this work. Nowadays x-ray photographs and infrared reflectograms make it possible to see the layers underneath without the need to remove the upper layers.

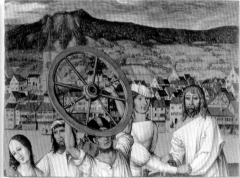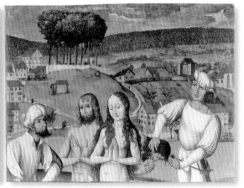

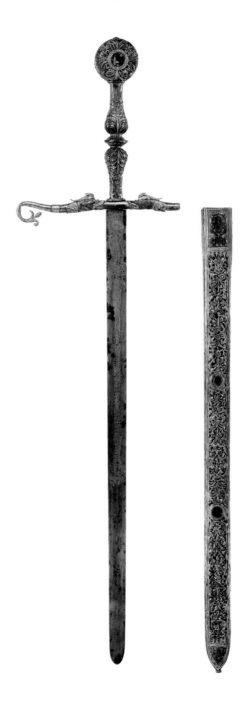

DOMENICO DI SUTRI
known to have been a goldsmith in Rome 1493–1511

Ceremonial sword, Rome, 1512

Silver, gilded, enamel
151.9 x 7.6 x 6 cm, broad handle 40.2 cm
Inv. no. Dep. 852, Swiss National Museum / Zurich Central Library

A CONSECRATED CEREMONIAL SWORD of this quality was presented as a gift only to princes or generals of aristocratic standing. On the way to the Pavia campaign, the Swiss troops were particularly honoured by Pope Julius II with the gift of this exceptionally valuable sword and numerous other items. For many years the 12 cantons of the Swiss Confederacy had been providing the pope with contingents of mercenaries for campaigns in northern Italy. Some 18,000 had marched into Lombardy in 1512. In the struggle for supremacy there, Julius II fought alongside the duke of Milan and the holy Roman emperor Charles V against the French. The experienced Swiss mercenaries quickly drove the French army of King Louis XII out of northern Italy, including Milan.

Impressed by their fighting power, in 1506 Julius II immediately founded the Swiss Guard to protect himself and the Vatican palace. It still exists and has the same function.

Swiss mercenaries had been both notorious and desired throughout Europe since the Burgundian Wars of 1476–77, when they defeated Duke Charles the Bold. Their technique was based on the pike square, a closed formation of infantry with the same number of men on all four sides. Some attacked first with pikes, then others breached the enemy ranks with halberds.

The oak leaves on the handle of the ceremonial sword refer to the arms of the Rovere, the family of the pope. The guard is decorated with two dolphins symbolising the Church. In 1507 a similar sword, also by Domenico di Sutri, was sent by Pope Julius II as a gift to King James IV of Scotland.

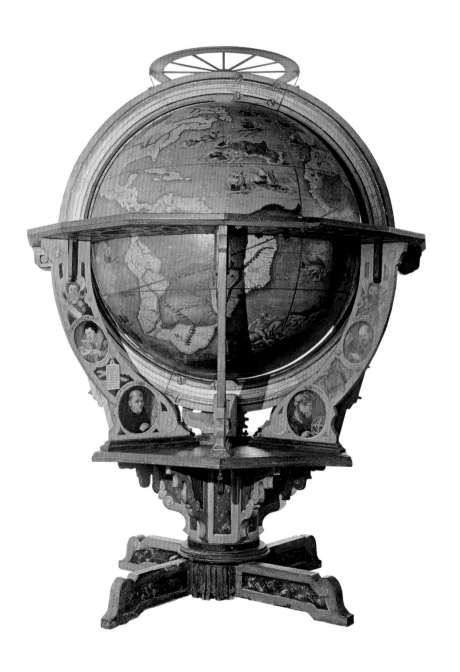

Terrestrial and celestial globe, known as the St Gallen Globe,
northern Germany, *c.* 1575

Globe: oil paint on a plaster ground over papier-mâché on wooden slats; stand: wood, painted
Circumference of the globe 380 cm, diam. 121 cm; stand: 233 × 174 cm
Inv. no. Dep. 846, Swiss National Museum / Zurich Central Library

THE ST GALLEN GLOBE is a unique example of globe-making in the Renaissance and one of the largest surviving globes from the sixteenth century. It is also war booty and has been the subject of a dispute about cultural property. The globe served mainly prestigious purposes, as is shown by the richly decorated wooden stand on which it is mounted. The sides of the frame are decorated with 14 portraits of astronomers, including Archimedes of Syracuse, the Persian Abd al-Rahman al-Sufi and the St Gallen monk Iso. The earth as depicted on the globe is based on Gerhard Mercator's world map of 1569. The maps of the northern and southern night sky go back to two woodcuts of 1515 by Albrecht Dürer. The pictorial programme is completed with topical events from world history, such as the Battle of Lepanto of 1571, early voyages of discovery, and representations of sea monsters and exotic animals.

The fact that the celestial and terrestrial globe has been in Zurich for centuries has been the subject of long and intense debate. In 1712, during the Second Villmergen War, a denominational struggle between the Protestant and Catholic cantons, troops from Zurich brought the globe and other cultural assets to their home city. After the signing of the peace treaty in 1718, Zurich arranged for the return of a part of these cultural assets. However, numerous manuscripts, paintings, scientific instruments, graphic works and the celestial and terrestrial globe were not included. St Gallen repeatedly demanded their return, but in vain. It was not until 2006 that arbitration by the Swiss government made it possible to reach an agreement: the original remained in the ownership of the Zurich Central Library and is exhibited in the National Museum Zurich. In return, the Canton of Zurich had a faithful copy made, which can now be seen in the Abbey Library of St Gallen.

JOST BÜRGI
(1552–1632)

Celestial globe, known as the **Bürgi Globe**, Kassel (Germany), 1594

Brass, gilded, cast, engraved, wrought, chased

H. 25.5 cm, diam. of the globe 14.2 cm

Engraved inscription on the underside of the ring: 'IVSTUS BYRGI Fecit Cassellis Anno 1594'

(made by Jost Bürgi in Kassel in the year 1594)

Inv. no. LM 59000

HUMAN BEINGS ARE CHARACTERISED by the urge to investigate and understand the universe. In the sixteenth century, the court of Landgrave William IV in Kassel was of key importance for the exploration of the heavens. The first permanently equipped observatory of the modern age was located in Kassel, where the mathematician and astronomer Jost Bürgi created this impressive globe. It shows the course of the sun, some 1,000 stars and 49 constellations. Inside it are two clockwork mechanisms and a dial showing the hours mounted on the north pole of the terrestrial globe. The globe unites astronomical and technical knowledge in a very small space and combines the greatest precision with exquisite craftsmanship. Four herms representing the ages of man grow out of the rotatable connecting piece above the circular stand. They bear the fixed broad ring in which the globe is mounted.

Jost Bürgi grew up in Lichtensteig in the Canton of St Gallen. Little is known of his career prior to the time of his appointment as clockmaker and astronomer to the Kassel court in 1579. He may have learned his skills in Strasbourg. In Kassel he was responsible for the construction and maintenance of astronomical instruments, clocks and globes, and he developed new measuring devices. In 1604 Emperor Rudolf II summoned him to Prague to be his court clockmaker. There Bürgi became friendly with Johannes Kepler and extended the study of mathematics. Among his most important achievements is the invention of logarithms – apparently independently of John Napier, although Napier published before him in 1614. Together with Tycho Brahe and Johannes Kepler, Bürgi also helped to change how the world was viewed. Thanks to a donation, his celestial globe has enriched the collection of the Swiss National Museum since 1978.

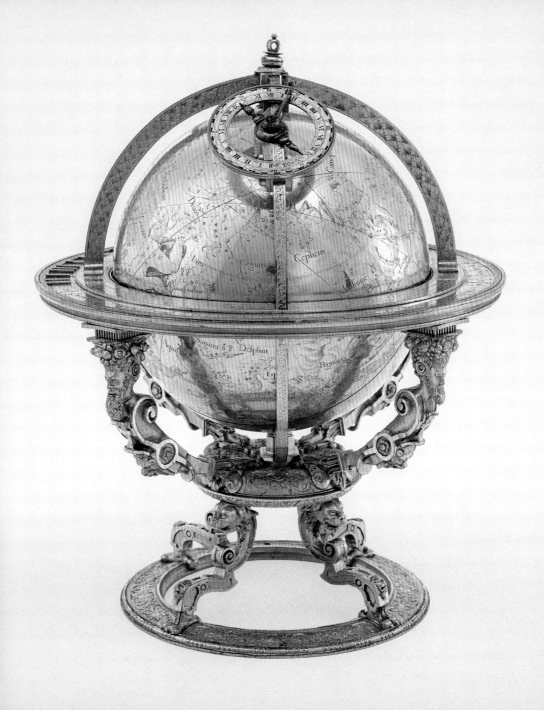

Probably HANS BALTHASAR ERHARDT
(1580–1636)

Halberd, Meilen (Canton of Zurich), *c.* 1606–1636

Iron, ash wood

216 × 23.5 cm

Inv. no. KZ 77

THIS HALBERD ORIGINATES from the stock of the Zurich armoury. It is just one of around 13,000 historical weapons, which have been coming into the collection of the Swiss National Museum since the 1890s as part of what is known as the 'morning gift'. Halberds were included in the equipment of the Swiss infantry in the Middle Ages and made the Swiss mercenaries famous. This all-purpose weapon was easy to handle and could be used for thrusting, stabbing, tearing and cutting. In battle it was employed against both cavalry and infantry. It was also inexpensive. This made it popular with the Swiss mercenaries, who were recruited from among the ordinary people of the cities and countryside and were obliged to buy their own weapons. From the fifteenth century halberds were usually furnished with a hook at the back, which may have made it easier to hack through the opponent's armour. In the fifteenth and sixteenth centuries, along with the pike, the halberd was the most important, and often the most crucial,

pole weapon of the Swiss warriors fighting abroad in the service of the most powerful rulers in Europe.

The halberd illustrated here is from the seventeenth century and is therefore part of a stock that was acquired by Zurich at the time of the Thirty Years' War (1618–48). However, as the city escaped the war, the weapon was not used. During the following decades, close combat weapons gradually became obsolete as the use of firearms increased, so this late acquisition remained in the Zurich armoury.

For a long time, halberds were a symbol of Swiss military prowess and the golden age of Swiss mercenary troops. Stylised halberds are still found on the badges of Swiss Army units and on municipal and family coats of arms.

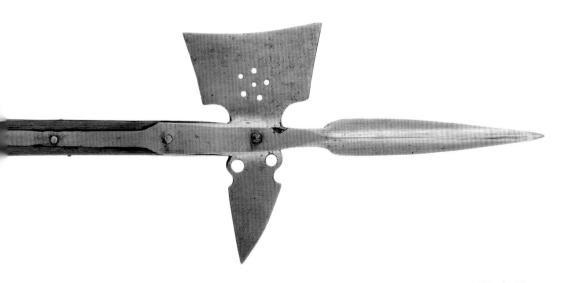

HANS WILHELM TÜFEL
(1631–1695)

Triton sleigh, Sursee (Canton of Lucerne), *c.* 1680
Wood, carved, painted, partially silvered and gilded, bronzed
185 × 278 × 120 cm
Inv. no. LM 19818

IN SWITZERLAND BETWEEN THE seventeenth and nineteenth centuries, anyone who owned a splendidly ornamented sleigh was a member of the aristocracy or the upper bourgeoisie and would use it for festive outings and at carnival time. Sleigh parades had been a popular form of entertainment at the European princely courts since the sixteenth century. Over the course of time, the prosperous classes copied the court lifestyle and had magnificent sleighs built for themselves. These were adorned with family coats of arms and local views or were even built in the form of mythical creatures. Animals such as stags, horses, lions and sea serpents were the preferred choices of decoration for these vehicles, which dashed through the snow behind galloping horses and were hung with sleigh bells.

The Swiss National Museum has a remarkable collection of ornamental sleighs, including this splendid example with the triton. It originates from Sursee in the Canton of Lucerne and has space for two passengers and a driver, who controlled one or two horses from his small leather seat behind the bench. The decorations relate to myths and legends concerning the sea: a triton blowing a seashell horn, sea serpents with gaping jaws, a figure of a fish with a wide-open mouth on the high-arched ends of the runners, and a seat shaped like a shell. The sleigh belonged to the Pfyffer family of Altishofen, whose wealth and reputation were built on the cloth trade and outstanding military achievements in foreign service. From 1652 on, this powerful family provided a total of 11 out of 19 commanders of the Pontifical Swiss Guard in Rome. The time they spent in the city on the Tiber probably inspired the decoration of the sleigh, as the triton motif can be seen on the baroque fountain in the Piazza Barberini in Rome.

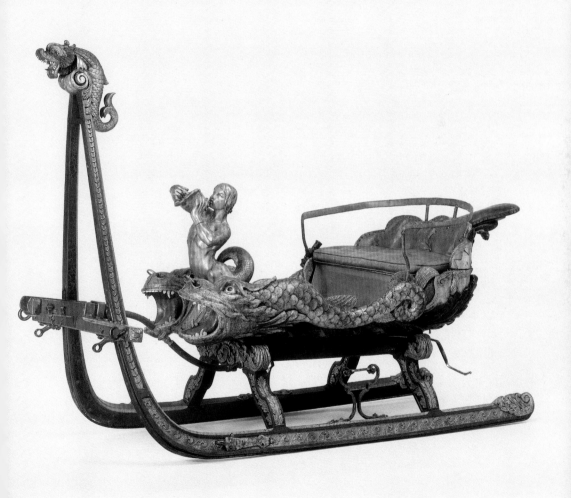

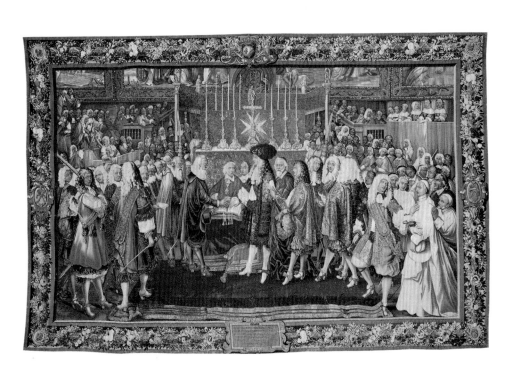

Alliance Tapestry, designed by Charles Le Brun (1619–1690)

Gobelins Manufactory, Paris, 1729–1734

Tapestry, wool, silk, metallic thread

387 × 585 cm

Inv. no. Dep. 65, Swiss National Museum / on permament loan from the Federal Office of Culture,

Gottfried Keller Foundation

THIS PRECIOUS TAPESTRY links Paris to the Swiss Confederacy, telling of power and war, fashion and customs, baroque splendour and alliances – an example of high-class self-promotion and one of my favourite objects, because of its wealth of different aspects. It originates from the 14-part cycle *L'Histoire du Roi*, celebrating important events in the life of Louis XIV. The scene portrayed here depicts the renewal of a mercenary alliance with the Swiss Confederacy that took place in the cathedral of Notre-Dame in Paris on 18 November 1663. Cardinal Antonio Barberini is seated at the centre, with the French king to the right and the assembled representatives of the Swiss cantons to the left. Louis XIV is the only one wearing a hat. To underline his pre-eminent position he had forbidden the Swiss ambassadors to appear before him with their head covered. Members of the French aristocracy are in attendance at the ceremony. More than 150 people can be counted on the tapestry, including few women. At the top right, Louis' wife Maria Theresa, his mother Anne of Austria and his sister-in-law Henrietta of England look on. The sober, dark clothing of the Swiss and their outmoded ruffs aroused some indignation at the royal court. Here two worlds collided: the magnificent, colourful baroque of the Catholic king's court and the sobriety of the Protestant Swiss cantons marked by strict moral restraint. This alliance enabled the Sun King to recruit up to 16,000 Swiss soldiers. Since the Burgundian Wars in the fifteenth century, the mercenary business had been Switzerland's most important economic sector after farming. At times, one Swiss soldier in ten was fighting in a foreign army. The Alliance Tapestry was acquired at a Paris auction in 1896.

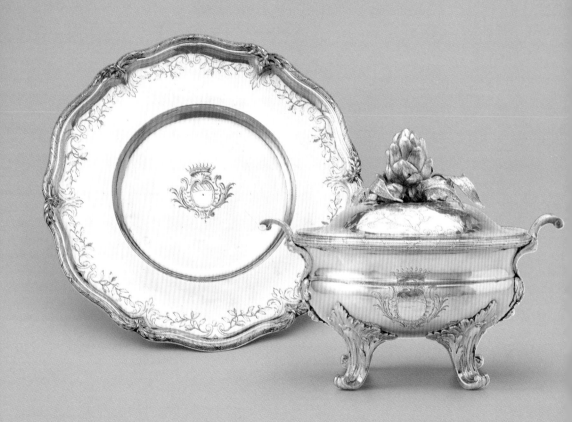

EDME-PIERRE BALZAC
(1705–1786)

Silver tureen, Paris, 1749

Silver, wrought, cast, engraved, chased

Bowl: 25.8 × 31.5 × 25 cm; tray: diam. 37.9 cm; total weight: 4.87 kg

Inv. no. LM 180747

IN THE EIGHTEENTH CENTURY, the courtly Parisian lifestyle made a strong impression on the Protestant upper class around Lake Geneva. This silver tureen with the artichoke-shaped knob and its tray were made in Paris for the Genevan Jean Jacques Ployard, who was descended from a French Huguenot family. His granddaughter, Julie de Thellusson-Ployard, inherited the precious piece, and it appears in an inventory of her property dated 1790. Julie's father-in-law, Isaac de Thellusson, was one of the most prominent members of the Protestant elite of Geneva, ennobled by the king of Prussia and owner of the estate of La Gara in the modern-day Canton of Geneva. After spending time in Basel, Amsterdam and London, from 1707 Isaac de Thellusson worked for his uncle Louis Guiguer in Paris at the Tourton et Guiguer banking house and became a very influential banker.

The magnificent bowl is of particular interest for our museum because of the Thellusson family's connections with Baron Guiguer, the builder and owner of the Château de Prangins. Julie de Thellusson and her husband stayed at Prangins, as witnessed by the diary of Baron Louis-François Guiguer.

Lidded bowls, decorated with vegetable motifs and the arms of the people who commissioned them, were the splendid centrepiece of many a table. This one is an outstanding example of the Paris-oriented lifestyle of an internationally connected Geneva family. Because of numerous French edicts in the eighteenth century demanding that silver be melted down, it is also an extremely rare object. Comparable tureens are preserved in the Louvre in Paris and in the Metropolitan Museum of Art in New York. It remained in the possession of the family until it was acquired by the Swiss National Museum in 2021.

AFTER PRINTED GRAPHICS BY FRANÇOIS BOUCHER (1703–1770),
JEAN-MICHEL MOREAU THE YOUNGER (1741–1814) AND OTHERS

Wallpaper with scenes from Ovid's Metamorphoses

Manufacture Arthur & Robert, Paris, after 1789

Origin: La Cibourg, Bernese Jura

Wood block print on paper, pine support, solid, glued

280 × 446 × 521 cm

Inv. no. LM 116903

THE HISTORY OF THIS WALLPAPER sounds like a crime story. Surrounded
by gently rolling hills, between La Chaux-de-Fonds and Saint-Imier in the
Bernese Jura, on a plain called La Cibourg, lies Bise Noire, an imposing
country house from the period around 1760. The 26-year-old wine dealer
Charles-François Robert and his wife moved into the house in 1795. They
decorated the salon with expensive wallpaper depicting scenes from
Ovid's *Metamorphoses*. Given the precision of the pattern, the quality
of the printing, the number of colours and the ingenious assembly, this
wallpaper undoubtedly comes from one of the great Parisian manufactur-
ers. How it arrived at La Cibourg is a mystery. Maybe its acquisition can

be explained by the fact that La Cibourg was
situated on a cross-border road and Charles-
François Robert was probably active as a
smuggler. That may have enabled him to buy
this work of art on one of his business trips to
France.

There are five known versions of this decor.
The one from La Cibourg is the only example
that has been preserved on its original support.
It also has the most diverse iconography. This
wallpaper hides an older wall covering with
landscape motifs, dating from the 1760s, which
makes it even more rare.

The Bise Noire remained in the possession of the Robert family for
generations. The estate was sold in 1955, and the salon, together with its
wallpaper, spent a little over fifty years in Valangin Castle. Eventually the
Historical and Archaeological Society of Neuchâtel donated the wallpaper
to the Swiss National Museum in 2011. After expensive restoration, it is
now exhibited in the Château de Prangins.

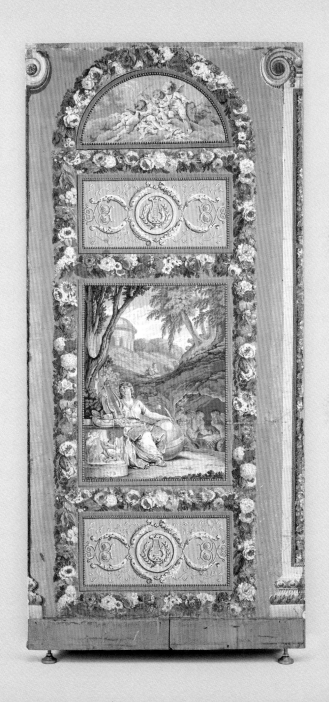

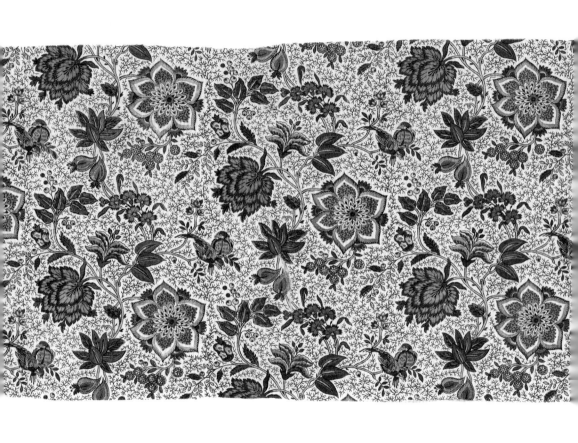

Indienne with flowers and birds, Oberkampf Manufactory,
Jouy, near Versailles, 1778–1787

Wood block print on cotton fabric

50 × 208 cm

Inv. no. LM 171675

FROM THE SEVENTEENTH century onwards, the taste for printed and painted cotton fabrics called 'Indiennes' because they originally came from India, spread through Europe. They were frequently used for interior decoration and for clothing. They were easy to maintain, comfortable to wear and partially affordable. As time went on, a European Indiennes industry developed and gained a foothold in Switzerland. In 1685, King Louis XIV repealed the Edict of Nantes, which had granted religious tolerance. Countless French Protestants fled to Switzerland – including pioneers in the production of Indiennes, who set up manufacturing businesses in their new homeland. In order to protect the French industry from competition, in 1686 King Louis forbade the import of Indiennes and their production in his kingdom. The Swiss manufacturers knew how to profit from this.

The fabric illustrated here was made in the Oberkampf Manufactory in Jouy, near Versailles, which was founded in 1760 by the German entrepreneur Christophe-Philippe Oberkampf. He had learned his trade in Switzerland, like so many others who had settled in France after the lifting of the ban in 1759. Swiss producers played a key role in the re-establishment of French cloth-printing. The pattern on the fabric is characterised by two-dimensional flower designs known as 'perses', which are reminiscent of the floral creations of Persia and the Mogul Empire. Swiss entrepreneurs also set up factories in Nantes, which produced Indiennes mainly for trade in West Africa. The fabrics were the chief currency employed in exchange for slaves. The Swiss National Museum holds a significant collection of Indienne fabrics, many of which are on permanent display in the Château de Prangins.

Goblet, Façon de Venise, late 17th / early 18th century

Colourless glass, base glued

H. 15.4 cm, diam. of foot 8.3 cm

Inv. no. LM 4616

THE TRADITION OF VENETIAN glass goes back more than a thousand years. The delicacy, transparency, elegance and ornamentation of these vessels still impress us today. Maybe we are also fascinated because glass was the first artificial material produced by humans, and because at certain times and in certain regions glassmaking repeatedly declined or even disappeared altogether. Venetian glassblowing reached its peak in the Renaissance, when it took a prominent position in the development of Western glass production. These luxury products of remarkable quality and astonishing transparency also found their way over the Alps into the palaces of kings and princes as well as the homes of the prosperous bourgeoisie. As a result of the high demand, numerous glassmakers outside Venice turned to imitating the popular products. The copied glasses are now described as *à la façon de Venise* (in the Venetian style).

Glasses consisting of a foot, a stem and a bowl, such as the goblet illustrated here, were among these imitations and are frequently found in Swiss collections. It is not possible to work out exactly where this glass was made. However, Swiss manufacture is conceivable, as similar pieces have been verified from archaeological excavations and from a local glassworks. This goblet is among those that were still thought to be Venetian products until the late twentieth century. One of its striking features is the construction of the stem, consisting of a glass bubble in the form of a baluster with the hint of a knop. Together with around twenty other goblets from the turn of the eighteenth century, it enriches the collection of the Swiss National Museum with its impressive and timeless form.

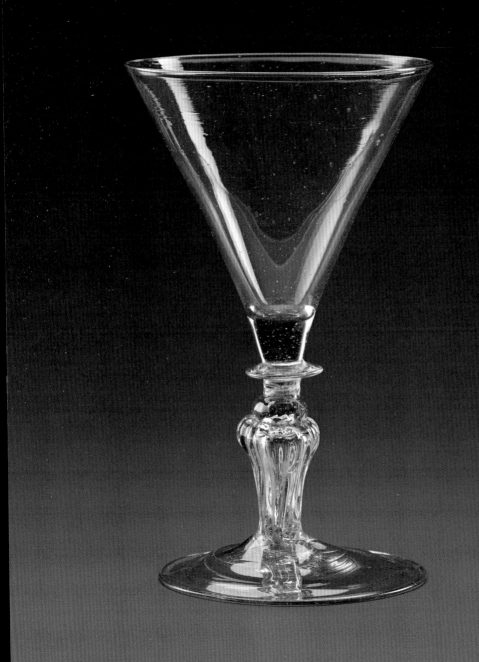

SAMUEL WALTERS
(1811–1882)

View of Johann Conrad Kuhn's ship, Liverpool, *c.* 1860

Oil on canvas

75.5 × 109 cm

Inv. no. LM 171746

THIS PAINTING TAKES us travelling halfway round the world. Johann Conrad Kuhn was born in 1808 in Thal (Canton of St Gallen), not far from Lake Constance. After training as a doctor, in 1833 he emigrated to Galveston, a small town on the Gulf of Mexico in Texas. Until the 1880s Switzerland was a country of emigration. Great poverty, but also the desire for adventure, prompted many to leave. North and South America were desirable destinations.

In Galveston, a trade and transport hub, Kuhn had a successful career. In 1846 he was appointed Swiss consul, and he was also active as a cotton trader. In 1859 the firm of S. Gildersleeve & Sons built the approximately 50-metre-long three-master in Portland, Connecticut. She was named *J. C. Kuhn* after the man who commissioned her. In 1860 the ship sailed to Liverpool with her first cargo of cotton. In the English port, Kuhn commissioned Samuel Walters, one of the leading English marine painters of his day, to capture his ship on canvas.

On the foremast flies the Swiss flag with the name of the ship, on the mainmast is the Texan flag, with the American flag fluttering from the back of the sail on the mizzenmast. Above it may be seen five more flags, which it has not yet been possible to identify. In August 1861 the American Navy in New York took over the capacious ship for use in the American Civil War.

The painting was acquired from the estate of Johann Conrad Kuhn's descendants and entered the collection of the Swiss National Museum in 2016. It is one of the works we will be examining more closely in the next few years with regard to Switzerland's involvement in colonialism.

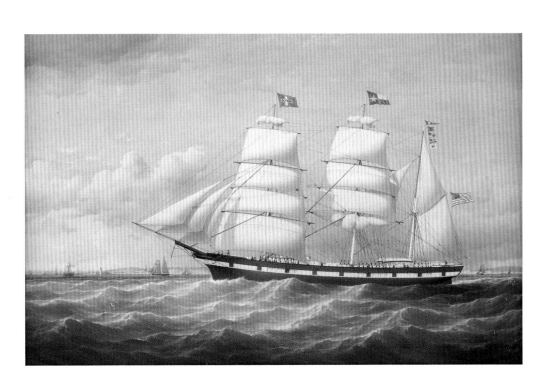

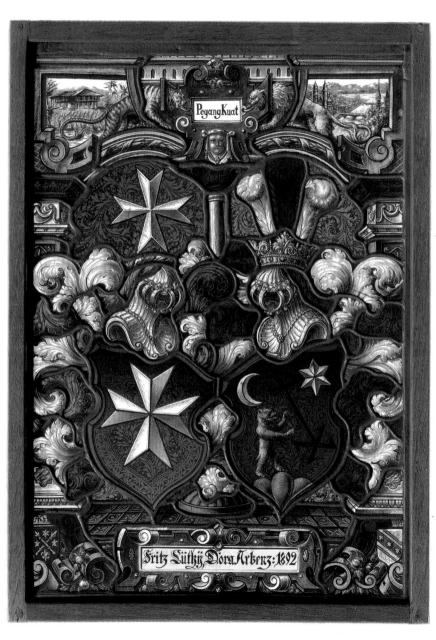

PegangKuat

Fritz Lüthÿ, Dora Arbenz: 1892

ADOLF KREUZER
(1843–1915)

Stained-glass marriage panel for Friedrich Alfred Lüthy (1851–1909) and Dora Arbenz (1871–1944), 1892

Schwarzlot / silver stain painting on glass, enamel painting; cames: lead, tin-plated

47 × 34 × 2 cm

Inv. no. LM 158621

THE OLDEST GLASS PAINTINGS in Switzerland go back to the thirteenth century and come from churches and monasteries. The Swiss National Museum houses one of the largest collections of glass paintings in Europe. After the general interest in what were known as *Kabinettscheiben* (stained-glass panels) had waned in the eighteenth century, it began to grow again in the nineteenth and twentieth centuries.

The stained-glass panel commissioned by Friedrich Alfred Lüthy of Solothurn in 1892 to mark the occasion of his marriage to Dora Arbenz, the daughter of a Zurich bank director, dates from this period. The Lüthys' coat of arms with the silver Maltese cross on a blue background and that of the Arbenz in red with a black family mark along with a bear under the moon and a six-pointed star, stand at the centre of the panel, symbolising the newly created alliance between the two families. The grisaille painting in the transom is informative. On the left it shows a house with a plantation in Sumatra. Friedrich Alfred Lüthy was a merchant who, together with Richard von Seuttner, ran the affairs of the tobacco-growing firm of Näher & Grob in Pagurawan (sultanate of Serdang) on Sumatra from 1879 to 1889. The majority of Indonesia had been under Dutch colonial rule since the seventeeth century. In the second half of the nineteenth century, many Swiss arrived on the Indonesian island of Sumatra. Most of them worked in the tobacco industry and took advantage of the land concessions, the lack of state institutions and the cheap labour of people forced into semi-slavery. As they extended their plantations, they drove the native people out of the areas where they lived. Friedrich Alfred Lüthy returned to Switzerland in the spring of 1890 with a considerable fortune.

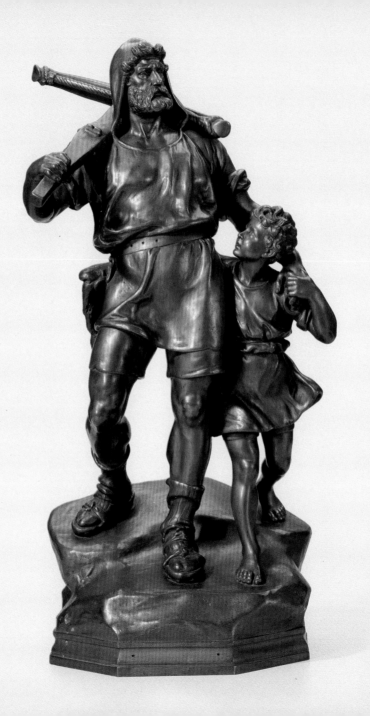

RICHARD KISSLING
(1848–1919)

William Tell with his son – artist's copy for the Tell memorial
in Altdorf, Zurich, *c.* 1895

Cast bronze

59.7 × 33 cm

Inv. no. LM 70640

SINCE THE LATE fifteenth century, he has been celebrated as the heroic
symbol of freedom in Switzerland's founding legend. He originally figures
in a Danish saga but, over the course of time, his story has captivated the
world. He has been built up into the champion of human rights and the
universal symbol of the fight for freedom. He is the hero of novels, plays
and films, material for satirists, and a motif on many objects that can be
decorated with an image. We are talking about the crossbowman William
Tell, who is said to have freed the Swiss from the rule of 'foreign reeves'
in the Middle Ages.

He is mentioned for the first time around 1470, in the collection of man-
uscripts known as the *White Book of Sarnen.* This tells of the Habsburg
reeve Gessler, who had his hat set up on a pole in Altdorf and commanded
the local townsfolk to salute it. Tell refused to do so and Gessler com-
manded him to shoot an apple from his son's head with a crossbow.
Because Tell had a second arrow in his quiver, which he had intended to
use to kill Gessler if he had hit his own son, the reeve had him bound and
transported by boat to his stronghold. However, Tell managed to escape
and shot Gessler during his flight.

After the great success of Schiller's drama *Wilhelm Tell,* first performed
in 1804, Tell became a Swiss national hero during the foundation of the
confederate state. That was the period of the most popular representations
of him. Among the best known is the monument by Richard Kissling in
Altdorf in the Canton of Uri. It glorifies Tell as the patriotic father and
shepherd. The competition for the design of the monument intended Tell
to be depicted as a proud, free man, bold and resolute. Kissling's statue has
informed images of Tell right up to the present day.

RENÉ LALIQUE
(1860–1945)

Finger ring, Paris, *c.* 1900

Chased gold, glass, pearl

2.4 × 2.1 cm

Artist's signature, engraved: LALIQUE

Inv. no. Dep. 11695

THE BODY OF A SNAKE IN GOLD surrounds a female figure of frosted glass. The snake, which is about to bite, symbolises temptation. On the other hand, in the context of Art Nouveau, the naked female figure stands for emancipation and the pearl to the right of her hip represents the apple that Eve plucked from the Tree of Knowledge in the Garden of Eden. The combination of glass – a non-precious material – and gold was extremely innovative around 1900 and distinguishes the skill of René Lalique, one of the most important French jewellers of the Art Nouveau period.

This precious jewel comes from the ring collection of Alice and Louis Koch, which has been in the Swiss National Museum since 2015 and on view to the public since 2019. The collection was originally comprised of almost two thousand rings dating from Antiquity to 1900. Over the past decades the fourth generation of descendants extended it with around six hundred works by twentieth- and twenty-first-century jewellers. It is now one of the largest of its kind.

In the late nineteenth century, the Jewish Koch family rose to become jewellers of international renown. In 1902, after the death of his brother Robert, Louis Koch took over the businesses in Frankfurt am Main and Baden-Baden and continued to run them successfully until his demise in 1930. His daughter Martha von Hirsch-Koch rescued the collection during the Second World War and brought it to safety in Switzerland. This was fortunate, as the jewellery business was soon expropriated by the Nazi regime.

The rings in the collection captivate us with the variety of their taste, symbolism, materials, techniques and design. They display a unique richness of imagination and individuality and testify to the powerful attraction of this type of jewellery.

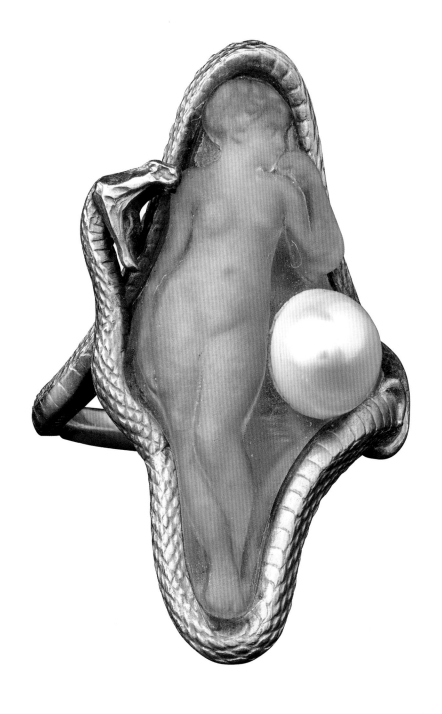

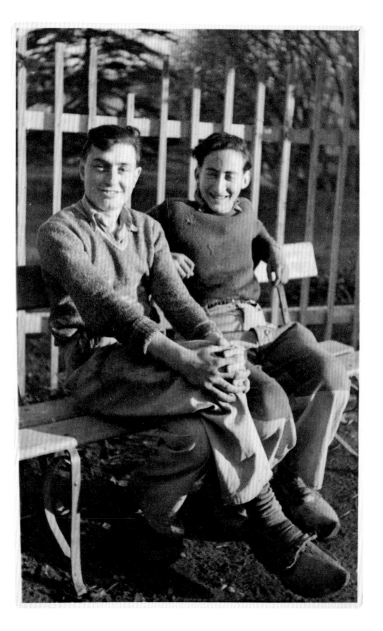

SEBASTIAN STEIGER
(1918–2012)

Kurt Klein and Joseph Dortort in the courtyard of the Château de La Hille, Château de La Hille, Montégut-Plantaurel (France), 1943

Black and white gelatin silver print on paper

13.25 × 8.25 cm

Inv. no. LM 91301.53

IN FEBRUARY 1941, the Swiss Red Cross (SRC) converted the Château de La Hille near Toulouse into a home for children and young people. In June it already housed almost a hundred young residents. The majority of them were Jews from Germany and Austria and had dramatic escape stories to tell.

In France, the mass arrests began in 1942. Young people over the age of 16 in particular were threatened with deportation. During a raid in La Hille in August 1942, dozens of residents of the home were taken away by the French Gendarmerie and transported to the Le Vernet concentration camp. With the help of the delegates of the SRC Children's Aid in southern France, the director of La Hille, Rösli Näf, succeeded in bringing the young people back to the home. In November 1942 the German Wehrmacht occupied the south of France. Subsequently a number of young people from La Hille tried to escape to Switzerland. One of them was Kurt Klein, born in Germany in 1925, on the left in the photo. Together with another resident from the home, he set off at the end of December 1942. They travelled by train up to the Swiss border, where they forced their way through the barbed wire by night and soon ran into Swiss soldiers. The latter took them back over the border to France as the Swiss border had been officially closed since August 1942. In addition, the Swiss did not recognise Jews as political refugees.

The SRC management learned of the failed escape attempt of the two lads from La Hille and immediately dismissed Rösli Näf. Kurt Klein soon joined the French Resistance and thus survived the war.

Evening sandals, Schönenwerd (Canton of Solothurn), *c.* 1945–1950

Producer: Bally Shoe Factory
Leather, stamped
20.5 × 13 cm; high heel: 7 cm
Inv. no. LM 77905

UNTIL THE MIDDLE OF THE nineteenth century, shoes were typically hand-made in the region of present-day Switzerland, though the business was commercially organised. The first shoe factory in Switzerland was established in 1847 in Winterthur. In 1851, Franz Carl Bally began producing shoes in Schönenwerd in the Canton of Solothurn. Prior to that, he and his brother Fritz had taken over their father's elastic and braces factory. The shoe factory experienced rapid growth. In 1860 Bally already had more than five hundred employees. A decade later, the company expanded beyond Switzerland and at the end of the nineteenth century the factory was producing around two million pairs of shoes a year. Nevertheless, Bally shoes continued to be considered a Swiss quality product for decades.

These gold sandals to go with full evening dress are a Bally creation. They were sold in a Bally shop in Paris in the first years after the end of the Second World War. The company name is inscribed in silver on the golden inner sole.

Shoemaking is one of the most important trades throughout the world and is rich in traditions. Shoes are among the most indispensable things in our lives. They protect our feet, support us and, not least, give us the opportunity to look fashionable.

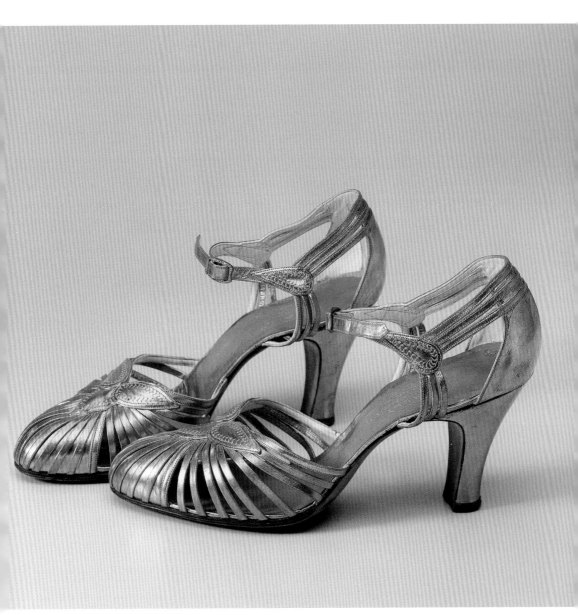

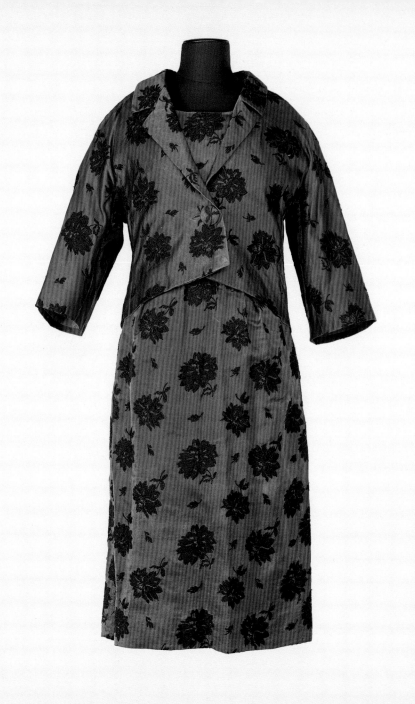

CRISTÓBAL BALENCIAGA
(1895–1972)

Cocktail dress, haute couture collection winter 1958

Silk, embroidered

Dress: 112.5 × 58 cm; jacket: 59 × 68 cm

Inv. no. LM 176943

CRISTÓBAL BALENCIAGA is one of the most influential fashion designers in French haute couture. His elegant, modern and innovative creations for self-confident women were very well received by the Paris fashion scene. In 1958 he was awarded the Légion d'Honneur for his services to the world of fashion. The cocktail dress illustrated here was created in the same year. It is an example of the luxurious clothing women were longing for after the deprivation of the war years. Its sculptural cut is characteristic of Balenciaga's work and reflects the peak of his creation.

The ensemble was acquired by the Swiss National Museum in 2019. Like many of the other fabrics that Balenciaga used for his creations, this fabric with its pattern of carnations on lilac comes from the Zurich textile firm of Abraham AG. Founded in 1878, the firm developed into one of the leading companies in the silk industry. Its creative work was documented in the second half of the twentieth century in an outstanding textile archive, which came into the collection of the Swiss National Museum in 2007. The archive – consisting of collection reference books, scrapbooks, lengths of fabric, fashion photographs and Lyon pattern books – sheds light on many different aspects of the world of textiles and fashion in the second half of the twentieth century and provides insight into the fascinating universe of high-quality designs, artistic innovation and international glamour. It is the visual memory of the company and now represents an inexhaustible source of inspiration and images for the future.

RUEDI KÜLLING
(born 1935)

Poster for BIC ballpoint, Zurich, 1961

Offset print, four colours

128 × 90.5 cm

Inv. no. LM 156539

IN 1950 THE FRENCH BUSINESSMAN Marcel Bich launched a cheap plastic ballpoint on the market, the now legendary BIC Cristal, which has sold by the million. This poster originates from the major advertising campaigns for this pen. It was printed by the Graphische Anstalt J.E. Wolfensberger AG in Zurich, which had been setting new standards in the graphics industry since the early twentieth century.

The poster was designed by Ruedi Külling, a successful graphic designer, creative director and entrepreneur. After starting his career in Milan under the aegis of the painter and graphic designer Franco Grignani, Külling made a crucial contribution to the success of the firm of Advico, one of the largest advertising agencies in Switzerland. He became famous for the packaging design for Cementit glue and the Sinalco campaign. In an interview with the Swiss National Museum, Külling told us: 'Drawing and writing with a ballpoint has a different quality from writing with a fountain pen. The ballpoint allows you to put a message on paper quickly and without blots. So, the visualisation idea was to scribble the name of the product with the product itself: with a BIC ballpoint on paper. That's how the BIC poster came about, with its design quality consisting of reduction to the essential.'

Thanks to cooperation between the Swiss Graphic Design Foundation and the Swiss National Museum, it has been possible to build up a significant collection of Swiss commercial art in order to preserve and disseminate the work of important Swiss graphic artists of the twentieth century. The BIC poster entered the museum's collection via this collaboration.

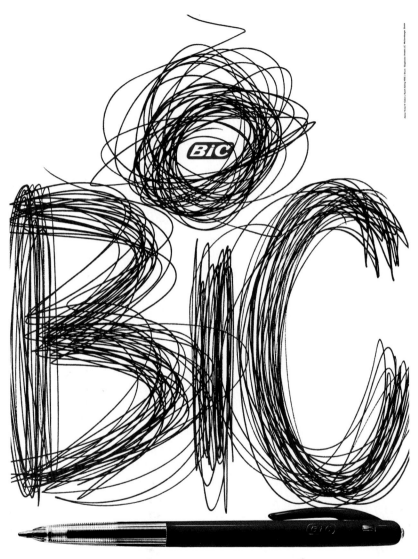

mit neuer Kugel

TRIX HAUSSMANN-HÖGL (b. 1933), ROBERT HAUSSMANN (1931–2021),
DUMENG RAFFAINER (1942–2005)

Bar cabinet Seven Codes, Zurich, 1978

Pear wood and maple intarsia, mirror glass

141.2 × 70 × 47.5 cm

Inv. no. LM 111970

THE BAR CABINET DESIGNED BY Trix and Robert Haussmann is a masterpiece of Swiss craftsmanship. The architect and designer couple influenced interior design for several decades, not only in Switzerland but also internationally. In the years they worked together, they produced furniture designs for various international companies and larger architectural and interior conversions, such as the Kronenhalle bar in Zurich, the redesign of Zurich's main train station and the Galleria shopping arcade in Hamburg.

The cabinet is part of the series of so-called *Lehrstücke* or didactic plays, which examine the study of ornament and the effects of imitation. The Haussmanns look back to the intarsia work of choir stalls, *studioli* and Renaissance furniture. The motif of the knotted cloth is reminiscent of the curtains in Byzantine mosaics and is an example of the manipulation of materials in the pear wood and maple bar cabinet. The hand-ground mirrors create a game of optical confusion. Trix and Robert Haussmann built this piece of furniture in collaboration with Dumeng Raffainer, the Swiss builder of architectural models, who made models for such architects as Santiago Calatrava and Peter Zumthor with millimetre precision.

The mirror cabinet was created in 1978, at a time when furniture was already mainly mass-produced. It is evidence of sophisticated design and virtuoso use of materials. It is part of the Swiss National Museum's extensive furniture collection, which displays regional differences and characteristics as well as the technical and formal development of furniture production in the various regions of Switzerland, from the Gothic period to the present day.

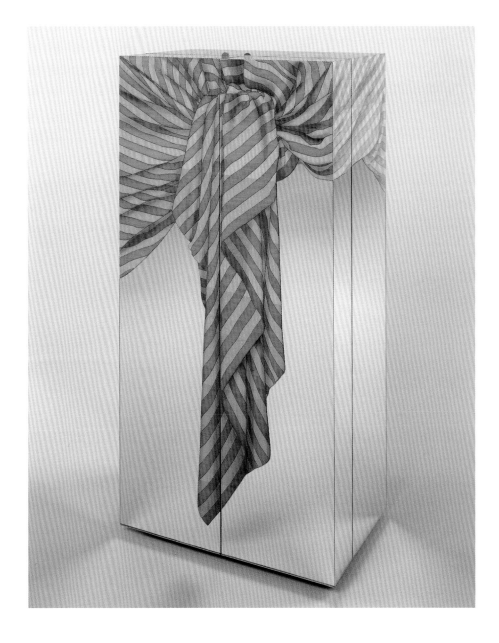

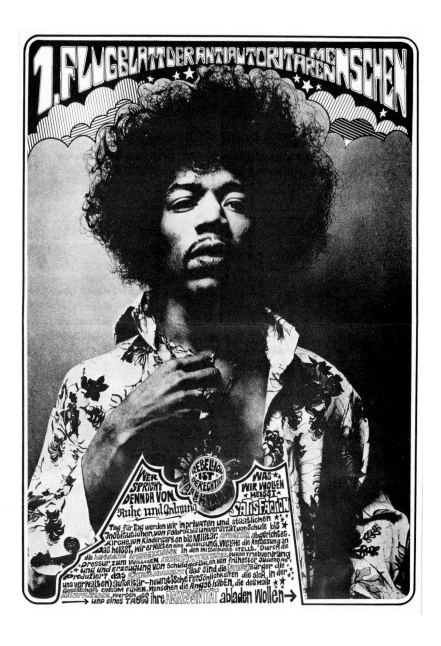

ROLAND GRETLER (1937–2018, text), LILO KÖNIG (text) and
PETER KÖNIG (b. 1937, graphics)

1. Flugblatt der antiautoritären Menschen (1st leaflet of the anti-authoritarian people), Zurich, 1968

Offset print on paper

41.9 × 29.8 cm

Inv. no. LM 174192

THE FRONT PAGE OF the *Flugblatt* of the youth section of the Partei der Arbeit
(PdA; Swiss Party of Labour) is a photograph of the American rock star and
singer Jimi Hendrix, and the back has photographs of the Rolling Stones
concert of April 1967 in the Hallenstadion in Zurich
and protest rallies in the city. The subjects of the
longer text, which is part handwritten and part typed,
include the 'satisfaction' the youthful rebels found in
the 'beat' of the time, the use of napalm in the Vietnam
War, the racism shown towards African Americans
in the USA and the discrimination against foreign
workers in Switzerland. The quotation 'Rebellion ist
berechtigt' (rebellion is justified) on the amulet Jimi
Hendrix wears around his neck is from a speech made
by the leader of the Chinese Communist Party, Mao
Tse-tung. Anti-authoritarian resistance is presented
here as the best way to achieve equal rights.

Since the mid-1960s, beat and rock music have
promoted new social movements. Demonstrations
for peace and against atomic weapons character-
ised the mood in many Swiss cities. Young people
demonstrated against capitalism and imperialism.
With new lifestyles, autonomous social centres and
their own newspapers, they fought against all things
authoritarian and for greater self-determination. The agenda of young
people in Switzerland also concerned many basic rights, such as the
right to abortion, the right to demonstrate and the right to participate in
decision-making. The youth culture of Jimi Hendrix's rock music became
the symbol of rebellion.

Whistle, Bern, 1969

Plastic, fabric, tin

4.8 × 1.8 cm

Inv. no. LM 116267

ON 1 MARCH 1969, the 'March on Bern' saw some five thousand women and men stream into the Bundesplatz in Bern. At 3.00 pm Emilie Lieberherr, the Social Democratic member of the Zurich City Council, stepped up to the microphone. She demanded 'immediate measures, to ensure that the women in our country also get to enjoy human rights'. Members of the Swiss Federal Council and members of parliament who rejected women's suffrage or did nothing to promote it were booed off the platform. That was where the whistle illustrated here came into use. The demonstrators' indignation was directed at the plan for Switzerland to join the European Convention on Human Rights (ECHR), which came into force in 1953. In 1968 the Swiss Federal Council wanted to join the convention – but with reservations: that is without guaranteeing equal rights for men and women – because women in Switzerland did not have the right to vote or the right to the same education as men. This threatened to further prolong the women's rights activists' struggle for equal voting rights, which had already been going on for over a hundred years.

The 'March on Bern' and the subsequent demonstrations by women committed to the cause, together with letters to parliament – such as that from Marthe Gosteli, the president of the Federation of Swiss Women's Associations – made it clear that the oldest democracy in the world did not have the right to deny the majority of the nation their human rights and helped the women's suffrage movement to make a breakthrough. Things then happened very quickly. At the end of 1969 the Swiss Federal Council introduced a bill on women's voting rights. On 7 February 1971 the men of Switzerland approved women's suffrage at the federal level. Switzerland was the penultimate European country in Europe to introduce equal rights for men and women. In 1974 Switzerland at last joined the ECHR.

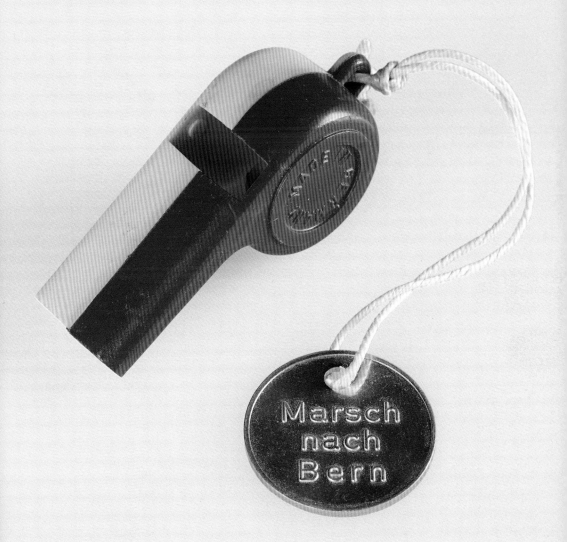

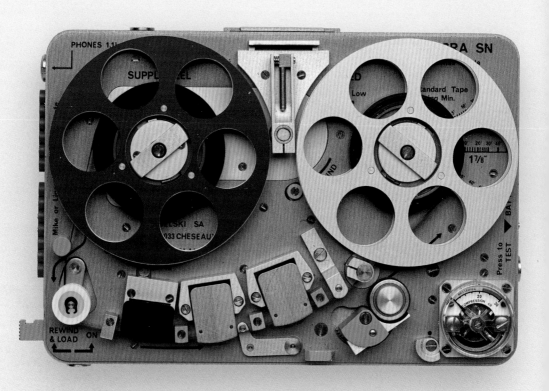

Spy voice recorder Nagra SN
Cheseaux-sur-Lausanne (Canton of Vaud), 1973

Aluminium

3 × 15 × 10 cm

Inv. no. LM 173996

NO BIGGER THAN A WALLET, accurate, reliable and robust – a miracle of analogue audio technology. The Nagra SN (Série Noire) was developed in the early 1960s by the Swiss firm of Kudelski as the smallest spy voice recorder in the world. It was commissioned by the US president John F. Kennedy, who was on the lookout for a small recorder for the CIA to make undercover sound recordings. The Nagra SN was delivered exclusively to them until the beginning of the 1970s. This small device is still functional, as demonstrated to me a few years ago, when I acquired it for the National Museum.

Kudelski AG, founded in 1951, soon made a name for itself with its portable recorders, which quickly won over the radio, television and film industries – as all these needed to make sound recordings on location. The founder of the firm was the engineer Stefan Kudelski, born in Warsaw in 1929. In 1939, at the outbreak of the Second World War, his family fled to Switzerland via Hungary and France. He built his first tape recorder during his time as a student at the École Polytechnique Fédérale de Lausanne (Technical University).

In the 1970s, the Nagra-SN devices were also used by the Swiss police, for example if they needed to record conversations of people whom they suspected of subversive activities. During the Cold War, the protection of the state and its population became increasingly important in the face of the nuclear threat. Counter-intelligence and surveillance were among the most important tasks of the Political Police – that is, the department that acted as the search and intelligence service for the Office of the Attorney General of Switzerland. Listening devices, bugs, mini radios and disguised cameras were used for this purpose.

URSULA RODEL (1945–2021)

Fashion sketch for Thema Selection, 1981

Half-length portrait of model in a shirt
Mixed media on paper and textile pattern
59.2 × 42 cm
Inv. no. LM 181180

PROMOTING WOMEN'S EQUALITY through fashion was unquestionably one of the aims of the Zurich fashion and costume designer Ursula Rodel. Her life was unconventional and intense: she was wild and a lesbian in a society that was still very conservative. She associated with stars such as Catherine Deneuve and Gérard Depardieu, worked on sets for Federico Fellini, and left her mark on the Zurich fashion scene into the 1990s. In connection with an exhibition on the women's movement in Switzerland, which I curated, I met Ursula Rodel in her studio several times. I was looking for fashion sketches like the one shown here, which Rodel had created for the fashion label Thema Selection, founded by her, Katharina Bebié and Sissi Zoebeli in 1972. This developed into the meeting place for the art and culture scene in the city. In 1974, American *Vogue* magazine reported that it was delighted by the label's avant-garde collection. The changing social conditions in the 1970s meant that emancipated women were crying out for new clothes. Ursula Rodel broke with the stereotypical male and female norms and revolutionised the Swiss fashion world. Her designs are distinguished by striking, timeless cuts and lines that emphasise the personality of the wearer. Functionality, as with the pale blue shirt, was in the foreground. After Ursula Rodel's death in the spring of 2021, the Swiss National Museum was able to acquire her important legacy of sketches, clothes and accessories, as well as photographs that depict her sphere and her circle of friends, and thus enlarge the collection with an important dossier on the history of Swiss women and fashion.

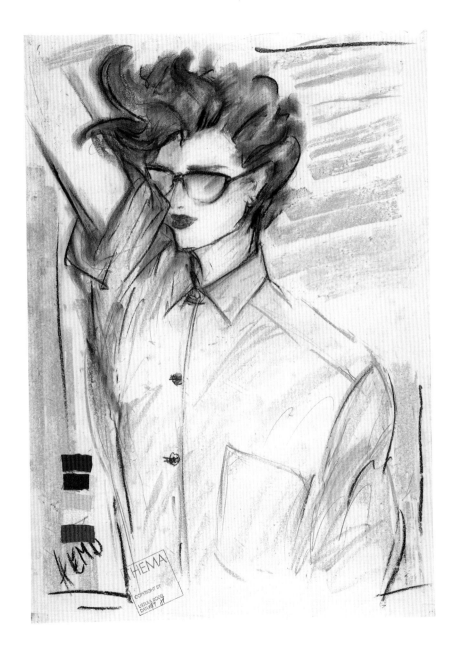

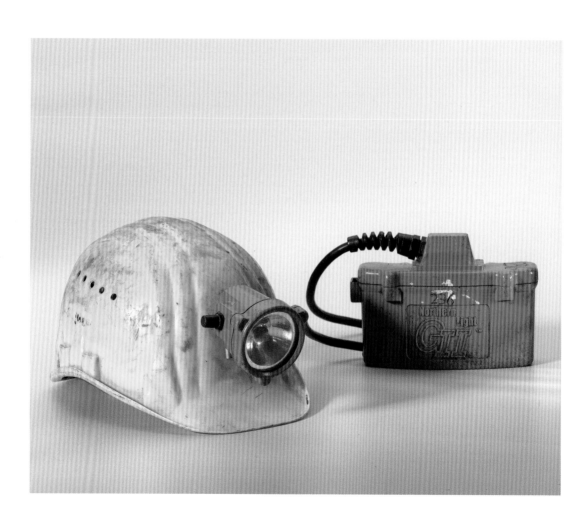

Tunneller's safety helmet with head torch and battery
Helmet: Germany, 2009; head torch: Canada, 2008

Helmet: plastic; torch with battery: plastic, aluminium, iron

Helmet: 17 × 31 × 21.2 cm; torch: 7.5 × 8.5 x 7.1 cm; cable: 133 cm; battery: 12.5 × 18.5 × 6.3 cm

Inv. no. LM 115392

AFTER 70 YEARS OF PLANNING and 17 years of building, the Gotthard Base Tunnel was ceremonially opened in 2016. The construction consists of two single-track tunnels with a length of 57 kilometres and connects the Canton of Ticino with the Canton of Uri. It is currently the world's longest rail tunnel and with the mountains above it rising up to 2,300 metres, it is also the deepest rail tunnel built so far. As part of the New Transalpine Rail Link (NEAT), the biggest construction project that Switzerland has ever undertaken, the centrepiece of the rail corridor between Rotterdam and Genoa is a masterpiece of engineering skill. The aim of this large-scale project, completed in 2020, is to move transalpine freight traffic from road to rail and thereby to a more environmentally friendly means of transport.

Two thousand tunnellers were involved in the construction of the Gotthard Base Tunnel. They worked in ten-day shifts, separated from their families and far from home. As before, with the building of many rail tunnels in the nineteenth century, all the miners came from outside Switzerland. In the case of the Base Tunnel they were mainly Germans, Austrians, Portuguese and Italians. The helmet illustrated, which enriched the collection of the Swiss National Museum as evidence of an epochal project from the most recent period of history, was worn by one of these tunnellers in 2010. The activity in the tunnel was demanding: the workers had to bore through various layers of rock – from hard granite to shattered sedimentary rocks – and they were exposed to the risks of flooding and high temperatures.

The project of the century, which cost 12.2 billion Swiss francs, has speeded up passenger travel and made freight traffic more efficient, as well as bringing northern and southern Europe closer together.

Slippers, before 2015

Wool, knitted, embroidered

22.5 × 9 cm

Inv. no. LM 169816

On the way to Diyarbakır, the second largest city in South-East Anatolia in Turkey, a Kurdish woman gave these slippers to G., a refugee woman, who has been living with her husband in Switzerland since 2015. They are *şimik*, hand-knitted house-shoes, worn by guests in Kurdistan when visiting friends and acquaintances. The advance of the jihadist IS fighters in northern Iraq compelled G. and her husband, who are members of the Yazidi minority, to flee in summer 2014. For the couple, that was the start of an odyssey that lasted a year and a half. After two weeks in the mountains, surrounded by the IS militia and with no food, they reached Diyarbakır, at first on foot and then with the help of a Kurdish group. Here the couple spent almost a year in makeshift tents. Because they could see no future for themselves, they decided to flee further. They sold their jewellery and collected money to pay a migrant-smuggler who drove them to Istanbul and from there took them on foot to Bulgaria. However, there they fell into the hands of the Turkish police, who sent them back. At the second attempt, hidden in the boot of a smuggler's car, the two managed to reach the Serbian border via Bulgaria. From there they travelled by taxi, smuggler's car and train through Vienna and Germany and in 2015 they reached the Swiss border. The dramatic story of their flight is powerful evidence of the humanitarian catastrophe that millions of people have had to suffer because of the civil war being waged in Syria since 2012.

The slippers are part of the area of the collection entitled *Zeitzeugen* (Witnesses to History). This covers social, political, economic and cultural events in Switzerland since 1945. The importance of the objects in this collection lies in the way they represent certain groups, trends, movements and events of contemporary history.

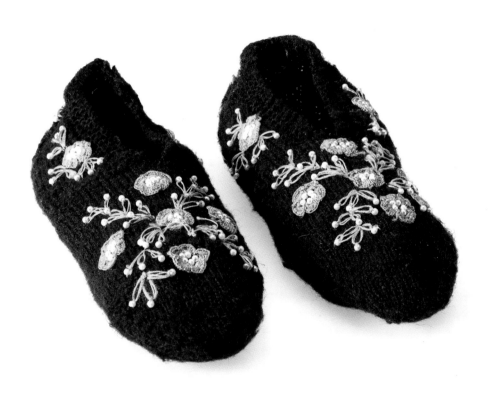

This edition © Scala Arts & Heritage Publishers Ltd, 2023
Text © Swiss National Museum, 2023
Photos © Swiss National Museum, 2023, except for:
p. 5 and 6 and front cover flap: Swiss National Museum, photo: Aura.ch
p. 8: Swiss National Museum, photo: Stefan Zürrer
p. 40 © Swiss National Museum / Gottfried Keller Foundation, Federal Office for Culture
p. 58 © Swiss National Museum / Alice and Louis Koch Foundation
p. 68 and 69: Swiss National Museum / Anne Gretler, Lilo König, Peter König

Specialist editing: Heidi Amrein, Helen Bieri Thomson, Beatriz Chadour-Sampson,
Andrea Franzen, Erika Hebeisen, Christian Hörack, Joya Indermühle, Christine Keller,
Pascale Meyer, Jacqueline Perifanakis, Mylène Ruoss, Daniela Schwab,
Christina Sonderegger, Luca Tori, Christian Weiss.

Translation from German by Rae Walter in association with
First Edition Translations Ltd, Cambridge, UK and Nigel Stephenson.
Editing, typesetting and proofreading in association with
First Edition Translations Ltd, Cambridge, UK.

First edition 2023 by Scala Arts & Heritage Publishers Ltd
305 Access House, 141–157 Acre Lane, London SW2 5UA, UK
www.scalapublishers.com

In collaboration with the Swiss National Museum
www.nationalmuseum.ch

Swiss National Museum ISBN: 978-3-905875-76-8
Scala ISBN: 978-1-78551-423-4

Project editing: Bethany Holmes
Design: Bobby Birchall, Bobby & Co
Printed in Turkey

10 9 8 7 6 5 4 3 2 1

FRONT COVER:
Ursula Rodel, fashion sketch for Thema Selection, 1981 (see pages 74–75)

FRONT COVER FLAP:
The National Museum Zurich

FRONTISPIECE:
Tunneller's safety helmet, 2008 (see pages 76–77)

BACK COVER:
Whistle, 1969 (see pages 70–71)